KINNICKINNIC
AVENUE

D0890956

KINNICKINNIC AVENUE

THE HEART OF BAY VIEW, WI

LISA ANN JACOBSEN

AMERICA
THROUGH TIME®
ADDING COLOR TO AMERICAN HISTORY

America Through Time is an imprint of Fonthill Media LLC
www.through-time.com
office@through-time.com

Published by Arcadia Publishing by arrangement with Fonthill Media LLC
For all general information, please contact Arcadia Publishing:
Telephone: 843-853-2070
Fax: 843-853-0044
E-mail: sales@arcadiapublishing.com
For customer service and orders:
Toll-Free 1-888-313-2665

www.arcadiapublishing.com

First published 2017

Copyright © Lisa Ann Jacobsen 2017

ISBN 978-1-63499-021-9

All rights reserved. No part of this publication may be reproduced, stored
in a retrieval system or transmitted in any form or by any means, electronic,
mechanical, photocopying, recording or otherwise, without prior permission
in writing from Fonthill Media LLC

Typeset in Mrs Eaves XL Serif Narrow
Printed and bound by CPI Group (UK) Ltd, Croydon, CR0 4YY

This book is dedicated to Linda Ann Travelstead, my most treasured friend who kept me always in her prayers, and saw her prayers for me come to pass.

CONTENTS

ACKNOWLEDGEMENTS

My sincerest thanks to the members of Bay View United Methodist Church who so kindly shared not only their photographs but also their memories. A very special thanks to Jean Larsen, who met with me before Sunday services and, outside of our meetings, took the time to write down her recollections. Virtually all the information in the Appendix was provided through Jean's efforts. I wish to thank the Pastor of the church, Andrew Oren, who contacted me via Messenger on Facebook in order to share a photograph. As a result of that contact, I then met Jean, David Evans, and others from the church. I am greatly indebted to Scott Schwarts, a direct descendent of the Schwarts family (Alfred is Scott's great-great uncle), for the use of photos and for sharing his family story and Gretchen Schwarts' recollections. I also wish to thank Kathy Mulvey, who so kindly assisted me in the archives of Bay View Historical Society, as well as my longtime friend Kathy Sena, who answered last-minute questions on photo scans.

Introduction

Bay View has a very rich and diverse history, so much so that it is impossible to cover all the deserving scenes and stories here in this one book. In order to narrow it down a bit, this volume will focus on aspects that involve Kinnickinnic Avenue, the main artery that runs through the center of Bay View. Originally an Indian trail that traversed north and south from Milwaukee to Chicago, Kinnickinnic Avenue was well utilized by Native Americans, European traders, explorers, settlers, and missionaries. Kinnickinnic Avenue, or KK, as it is known by Bay Viewites, witnessed virtually all aspects of local history, including the beginnings of the French fur trade, the influx of pioneers and the settling of the area, the presence of Freemasons and Good Templars, as well as America's first labor strike in 1886. Today, KK remains the main artery of Bay View, and bustles full of restaurants and specialty shops, nightclubs and residences, most of which are housed in buildings that still stand today just as they did when first constructed many years ago. This book will feature images of both the past and the present and, in regard for those polled as to what they preferred to be included in this volume, an interesting and lighthearted social history of the neighborhood they have come to love.

Beginning at the fork at Mitchell Street which separates First Street and Kinnickinnic, we will travel southward up to and including just slightly past Oklahoma Avenue. Also included are photos of the KK River as well, although not directly on KK Avenue. I realize my selections will not please everyone. My apologies in advance for those images left out; it was a difficult process determining exactly what to include and what to leave out. Upon starting this project, I was fearful that I wouldn't have enough material. Within a very short period of time I knew this fear was completely unfounded, for there is ample material available on the history of Kinnickinnic Avenue.

1

Beginnings

Kinnickinnic Avenue. To many lifelong Bay Viewites, the name evokes fond memories and colorful imagery of marching high school bands and drug store soda fountains. To a newer population, it's a modern main drag filled with a variety of restaurants, shops, and nightspots. Regardless of residential tenure, Kinnickinnic Avenue *is* Bay View. Intertwined in an assortment of beliefs and opinions, cultures and norms, elders and millennials, Kinnickinnic Avenue is representative of the changes and challenges, growth and expansion, variety and diversity that is America, and thus shares a history with our nation as a whole. This shared history is easily observed throughout our country … one city, one neighborhood, one street, at a time. Distinct yet united, combined and mixed together, both the historic and the modern all blended into our American culture, just as it does on Kinnickinnic Avenue. Ironically, most sources indicate that "Kinnickinnic" is a Native American word meaning "it is mixed," in reference to the dried leaves, bark, and tobacco that was mixed and smoked. Thus, "it is mixed" continues to live up to its name. But what were Kinnickinnic Avenue's beginnings? What is the story behind this street that all Bay Viewites consider home and is representative of American history? To answer this question, a very brief look at the history of our nation's beginnings becomes necessary.

The fur trade, more than any other activity, contributed to European exploration of North America, including the Great Lakes region, opening vast treks of land west of the Mississippi River. As explorers moved further inland from the Atlantic coast, the first European traders to reach the Great Lakes region were French fishermen who, during the fourteenth century, had fished off the coast of north-eastern Canada and, at that time, only occasionally traded with the Indians. In time, however, trading became so profitable that many completely abandoned fishing and instead made voyages to North America solely to trade in furs. The fur trade involved the geographic area that would become Wisconsin, including the small trek of land on the southwestern shoreline of Lake Michigan that would become Milwaukee and Bay View. *The Conspiracy of Pontiac,*

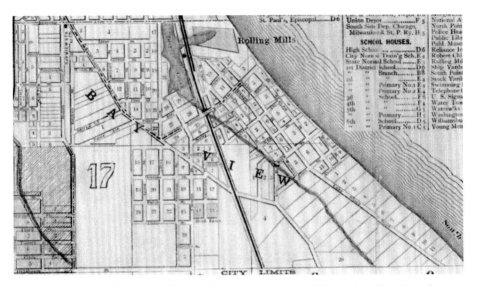

Map from American Geographical Society Library—University of Wisconsin-Milwaukee Libraries.

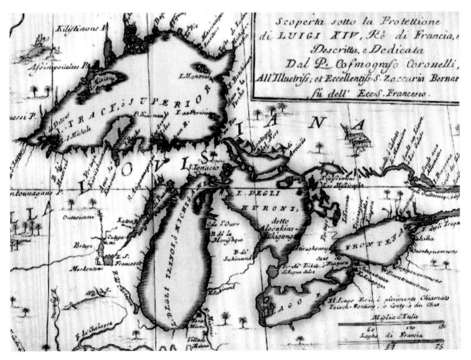

This map of the Great Lakes is written in French, the language of the first group of fur traders to reach Lake Michigan and the Milwaukee area, such as Solomon Juneau.

written by nineteenth-century historian Francis Parkman, is by far the most captivating account on the fur trade, and is highly recommended reading. In this beautifully written, sweeping narrative, Parkman describes the Indian as a child of the forest whose "haughty mind is imbued with the spirit of the wilderness … his unruly pride and untamed freedom are in harmony with the lonely mountains, cataracts, and rivers among which he dwells."

While these descriptions could be interpreted to imply negativities, further reading reveals a respect, an almost breathlessness of feeling, toward the Native Americans: "Primitive America, with her savage scenery and savage men, opens to the imagination a boundless world, unmatched in wild sublimity." This stirring description, while suggesting a partiality toward American Indian culture, cannot be disregarded. In his research Parkman not only consulted various documents such as letters, journals, and reports, but also "visited and examined every spot where events of any importance in connection with the contest took place, and … observed with attention such scenes and persons as might help to illustrate those I mean to describe … the subject has been studied as much from life and in the open air as at the library table."

Parkman's first-hand, personal experience with his subject undoubtedly contributed to has awe-inspired view of the Native American Indians.

Fur trading posts had flourished in Chicago, Detroit, Milwaukee, and Montreal, and each were followed by large settlements. The French fur traders that traversed the Great Lakes brought with them Catholic missionaries and first landed at Milwaukee as early as 1674. It is known that Father Jacques Marquette reached the Bay View area during that year, and visited with the Native American Indians of Jones Island.

In 1699 Father Jean Francois Buisson de St. Cosme came to the area and travelled through the bay at Milwaukee and landed at the mouth of the Kinnickinnic River. He

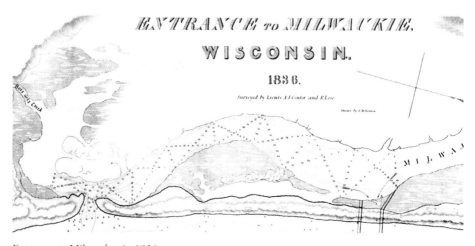

Entrance to Milwaukee in 1836.

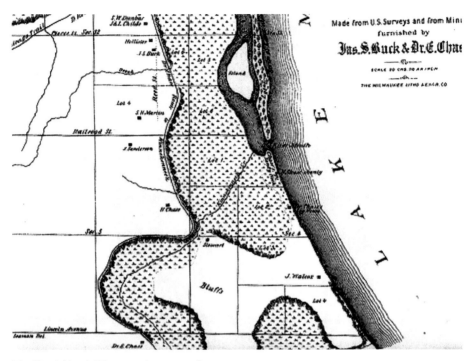

The Kinnickinnic River seen in center of map.

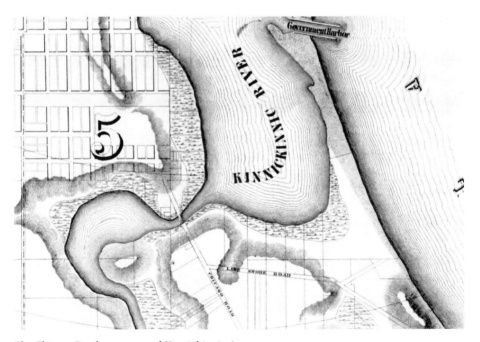

The Chicago Road was renamed Kinnickinnic Avenue.

wrote in his journal that they stayed on the KK River for two days because there was an abundance of duck and teal.

There was no permanent European settlement in Milwaukee until 1795 with the arrival of fur trader Jacques Vieau. Vieau sent for help in his enterprise and, on September 14, 1818, Solomon Juneau arrived, destined to become Vieau's son-in-law and Milwaukee's first mayor. Byron Kilbourn came to Milwaukee soon afterwards and settled on the west bank of the Milwaukee River, opposite Vieau and Juneau. George H. Walker followed in 1834, and built his log cabin settlement south of the river. These three men are considered the founding fathers of Milwaukee. However, on December 4, 1834, three travelers left a trading post in Chicago and headed north on a well-known and well-used Indian trail, arriving at Milwaukee four days later. Those three travelers were Horace Chase, Samuel Brown, and Morgan L. Burdick, all three of which were surely ignorant of the fact that they would be the founders of the future settlement of Bay View. While there is no historical evidence to show the trail Chase, Brown, and Burdick traversed to get to Milwaukee was in fact the KK Trail, it is hard to imagine they came by any other route. The KK Trail brought many a pioneer into Milwaukee from the southern Chicago, virtually the only trail passable with horse and wagon. Prior to this time Wisconsin, including the region that would become Bay View, was a wilderness, a veritable part of the Western Frontier to which many would make an arduous journey in the hopes of homesteading and farming to carve a better life for themselves and their families.

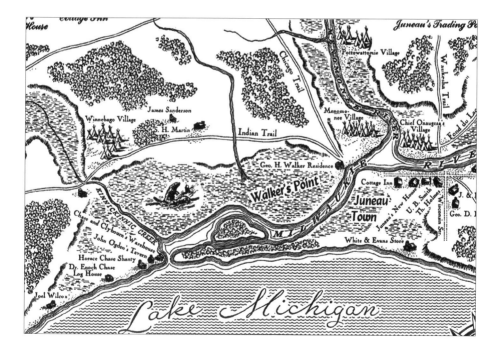

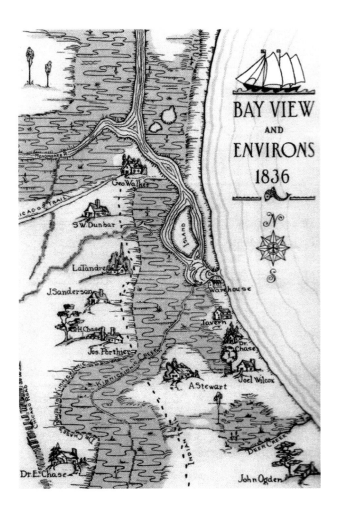

Having been engaged in the surveys of the Wisconsin Territory and … also in possession of the Plats and Surveys of those parts of it which are in market to further … the settlement of the country promoted by the establishment of such an agency, where both buyer and seller may find the means of satisfactory purchase or sale … I tender my services to the public.

So stated Byron Kilbourn in a notice in *The Weekly Wisconsin* in July of 1836, twelve years before Wisconsin would become the 30th state in the Union. Announcing the sale of land to the public, Kilbourn was himself a land speculator.

Sources show that in 1840, following Kilbourn's notice of land for sale, Enoch Chase was advertising a farm for sale in the *The Milwaukee Sentinel* four years later and, in 1877, an advertisement in the *Daily Milwaukee News* lists a row of small houses on Lincoln Avenue between KK and Bay View Street worth $500 to $2000 each.

 While there was no settlement population in Milwaukee in 1835, only those families
mentioned above lived among the Native Americans. By 1843, however, the population
had grown to 6,068, and by 1847 it had reached 14,061. In 1850, the same year the fur trade
came to a close, the population of Milwaukee had more than tripled to 20,065. Comparing
this to the 30,448 people in New York in 1855, it is easy to see that the Milwaukee area
was growing very fast.

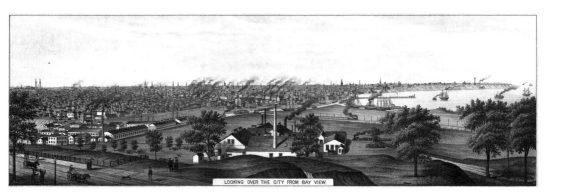

LOOKING OVER THE CITY FROM BAY VIEW.

2

SETTLEMENT AND GROWTH

THE GEOGRAPHIC AREA that would become Bay View was one of farmlands and fishing along with trade among the Native American Indians, and KK was merely a cow trail that winded through the surrounding fields and wilderness. Outside of this small locality, however, the steam engine, the cotton gin, and the telegraph were being invented. And, in January 1855 the invention that would become the most significant to this area was being perfected: the Bessemer Method for processing steel from iron. This would change the lay of the land forever, for the main reason Bay View proper came into existence was the building of the Milwaukee Iron Company rolling mill in 1868. Further, as a result of the mill, immigration to both Bay View and Milwaukee increased, and the population grew.

On May 6, 1886, the newspaper *The Weekly Wisconsin* reported that the labor troubles resulting from the eight-hour movement had kept Milwaukee in a tumult for at least a week. On May 1, thousands of people quit work on Saturday and on Monday a crowd of about 2,000 went to the Mill demanding and threatening to tear the Mill down, which resulted in the dispatch of the WI Fourth Battalion. The day ended peacefully, but on the next day, May 5, strikers returned to the Mill in a riot and were fired upon by the militia, killing seven people. This day is locally remembered as The Bay View Massacre.

Many families that came to Bay View stayed for a lifetime, building both their family and their business. A perfect example of this is the Schwarts family, the descendants of which are still in the area. Scott Schwarts, great grandnephew of Herman Schwarts, writes:

Herman and Mary Schwartz were married in Milwaukee in 1864. Herman was a horseshoer during the Civil War and Mary was born on Wisconsin Avenue (potentially Grand or Spring Street at the time) in 1848, the year Wisconsin became a state. The Schwartz's ran a stable which was located behind their home at what is now 2939 S KK. The house was torn down a

few years ago but there is a photo of it before that happened attached as well as one showing it as it originally looked. They opened a blacksmith shop on Lincoln Avenue and went into the excavating business after the depression. Schwartz Excavating owned one of the first steam shovels in the area and dug the basements of many homes on Oklahoma Avenue as well as the lower levels of Pulaski High School.

Scott continues:

> The Schwartz homestead was at 1615 S KK (now 2939). There are 2 houses at the location and this is the smaller one set back from the street on the right. Not sure who the people are in the photo. Potentially Herman Schwartz on the right. A visit to the owners dates the house to 1886. This is yet to be confirmed. Sadly, the house was torn down without notice on March 26, 2013. During World War II, Alfred Schwartz, Herman and Mary's son, was considered one of the foremost authorities on horses. He was tasked by Schlitz to build teams of horses for beer deliveries during gas rationing.

Of the first things constructed in any town or village is the church, the school, and the tavern, not necessarily in that order. Other businesses would naturally follow close by.

Kinnickinnic Avenue naturally became the main street of Bay View, and early on filled with a variety of grocers and bakeries, dentists and doctors, and department and hardware stores, as seen in the following photos. Many of these structures still stand today and are home to current business owners, maintaining the popularity of KK from its inception as an Indian trail and throughout European exploration and pioneer settlement, transforming into Bay View's main street in the 1800s, and providing for the area's residents during the growth of The Mill. On Saturday, November 18, 1899, *The Weekly Wisconsin* reported:

> these are prosperous times for the iron workers … at Bay View … who are paid according to what is known as a "sliding scale." That is, the employers agree to pay them so much a ton for working the iron when the selling price is so much a ton. If the selling price goes up or down the wages follow. A dispatch says that the wages in the Steel company's rail mills, under present contracts at $35 per ton for rails, will break all records. They will now earn from $150 to $300 per month. The highest wages ever paid in any previous year was in 1882 when steel rails sold for $20 a ton.

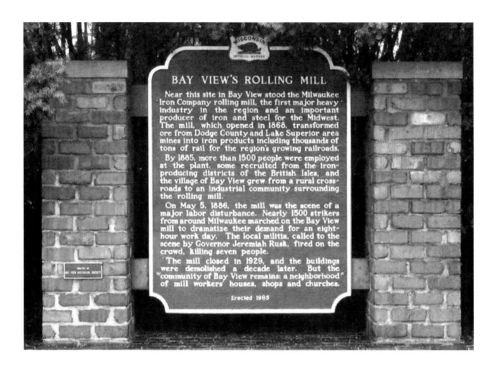

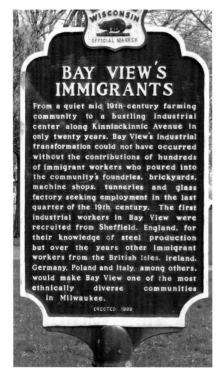

Above: Historical marker for Bay View's Rolling Mill.

Left: Historical marker for Bay View immigrants.

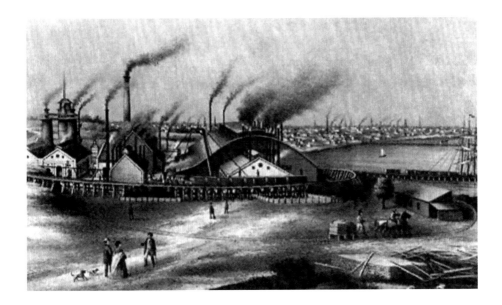

Above: The Rolling Mill.

Right: The Milwaukee Iron Company rolling mill. *(Courtesy of James Bisenius)*

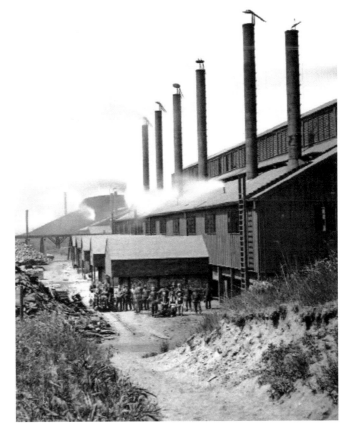

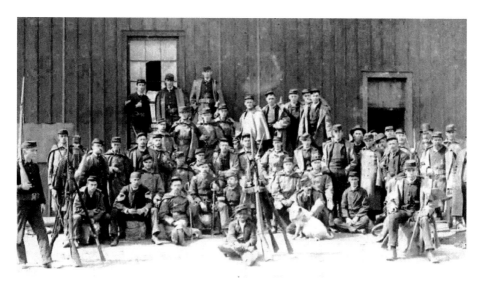

Troops called due to strikers at the mill. *(Courtesy of James Bisenius)*

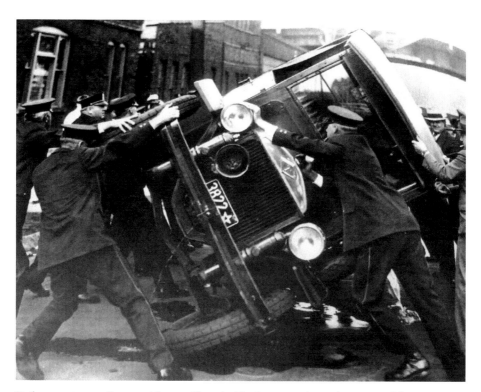

Strikers overturn police car with two officers inside. Sources indicate this is part of the occurrence in Bay View but it may be in a different area in Milwaukee, as strikes were occurring elsewhere in addition to the Bay View Mill. *(Courtesy of James Bisenius)*

RIOT OF DEATH

The Militia Fire Upon the Mob
at Bay View Today.

Men and Boys Die in
Their Tracks.

Six or Eight Rioters Fatally Injured.

Various Opinions as to the Necessity of Shooting.

Policemen in Conflict With a Boisterous
Crowd on the West Side.

No Serious Trouble Experienced at the
Works of E. P. Allis.

Trouble at the Stock Yards Settled in Short Order.

No Further Trouble at Bay View This
Afternoon—Brewars Closed—Veteran Volunteers.

(Courtesy of James Bisenius)

Schwarts home, now on 2939 KK. *(Courtesy of Scott Schwarts)*

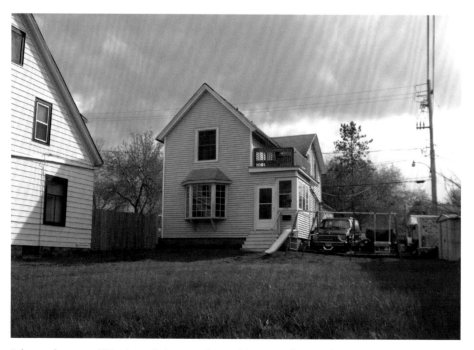

Schwarts home on KK prior to being torn down. *(Courtesy of Scott Schwarts)*

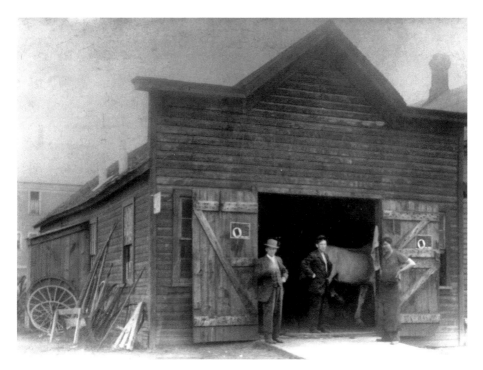

Schwarts blacksmith shop. Sources indicate shop was on Lincoln but may have been on KK according to family papers. Alfred Schwarts on right. *(Courtesy of Scott Schwarts)*

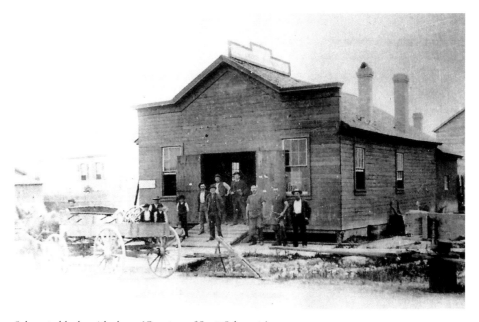

Schwarts blacksmith shop. *(Courtesy of Scott Schwarts)*

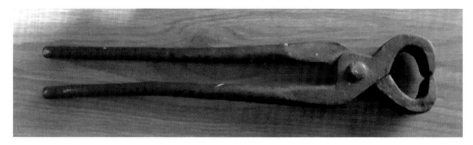

Clippers used in the Schwarts blacksmith shop. *(Courtesy of Scott Schwarts)*

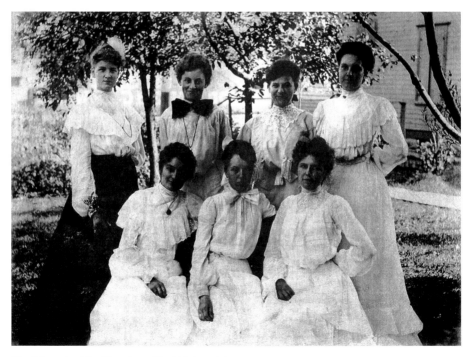

The Schwarts girls. *(Courtesy of Scott Schwarts)*

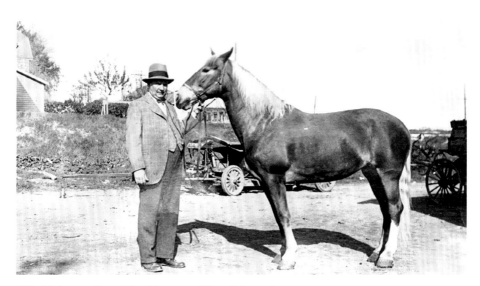

Alfred Schwarts, June 1937. *(Courtesy of Scott Schwarts)*

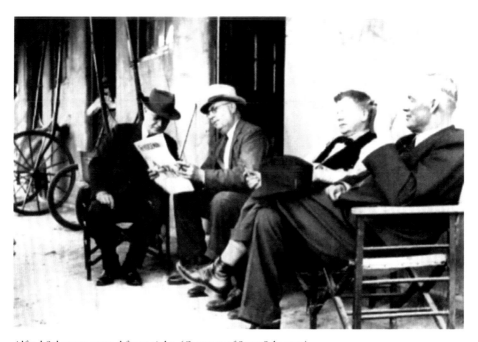

Alfred Schwarts second from right. *(Courtesy of Scott Schwarts)*

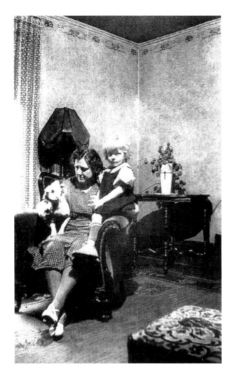

Catherine Schwarts with Gretchen and family dog. *(Courtesy of Scott Schwarts)*

Gretchen Schwarts at 2939 S KK, 1936. *(Courtesy of Scott Schwarts)*

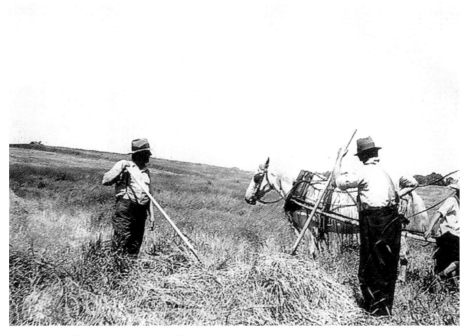

Schwarts family haying. *(Courtesy of Scott Schwarts)*

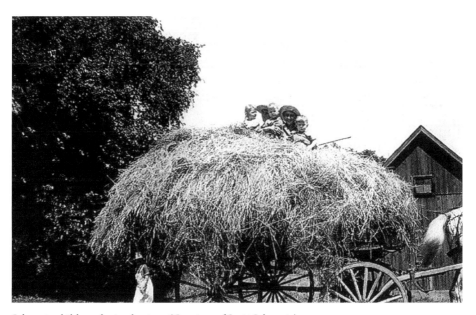

Schwarts children during haying. *(Courtesy of Scott Schwarts)*

War's Over, Brewery Horses Again to Pass Into History

One of the last bits of historic Milwaukee, resurrected with the advent of gasoline rationing, is about to pass back into history. The Joseph Schlitz Brewing Co. announced Saturday that its 16 Belgian horses, used during the wartime emergency to haul beer kegs and cases for city delivery, are for sale.

There are two ways of looking at the matter. There is the view held by Frank Dreyer, superintendent in charge of the keg beer department. And there is the opinion of Alfred Schwarts, boss of the barn.

Dreyer likes the horses. They are beautiful, perfectly matched, and did a good job of substituting in the emergency. He doesn't like to see them go, because they are a part of the traditional brewery, what with the fancy harnesses and stout brewery wagons. But these days the folks want their suds delivered on the double, and art and tradition do not enter into the picture where speed is king.

Schwarts, however, is different. He bought his first horse when he was 12 and lived in the country around Lincoln and Kinnickinnic avs. He has lived in Milwaukee all his life, and all his life he spent working with, buying, selling, trading, running and judging horses.

He was standing in the barn, talking to Dreyer.

"Y'know, Fred, it's a shame to sell that pair of geldings there. Why,

they won second place at the Illinois fair last year." He turned to a trio of roans. "And you can't have them!" he announced firmly. He went into each stall, calling the horses by name, pointing out how fine and beautiful they were.

He remembered things each horse had done. Buck and Dick one day pulled a train carload of tight packed sawdust. "Must have gone a good 10 ton," he said. Every team

had pulled loads of seven ton regularly.

More horses came in, to be watered at the porcelain water trough in the barn at 1708 N. Commerce st. Again, Al remembered reasons for wanting to keep them. "That trio pulled a load of blood donors one day. Prettiest picture you ever did see," he said.

Finally, grudgingly, Al agreed that if the "big boys" wanted the horses sold, they would have to go. But he grumbled on. "It's really a shame to sell horses like that. Why, this barn has the finest Belgian horses in the state. I was offered $1,000 for Dick last year, and I wouldn't part with him. It's really a shame."

Al said the horses would probably be sold for $500 or $600 a team.

"But they better leave some of my horses here for me," he said darkly.

"If they don't . . ." he scowled as heavy scowl as a laughing face can scowl . . . "I'll . . . I'll burn the barn d— n em!"

"Good-by, pal," says Alfred Schwartz —Journal Staff

Left: Alfred Schwarts *Milwaukee Journal* article, date not known. *(Courtesy of Scott Schwarts)*

Below: Alfred's Schlitz Team. *(Courtesy of Scott Schwarts)*

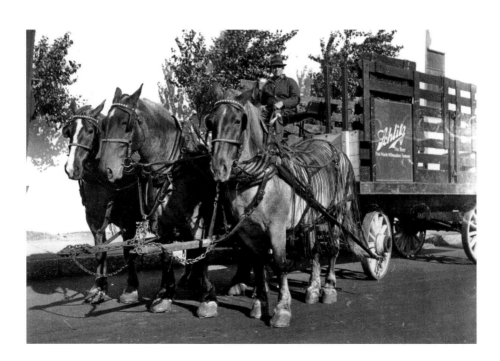

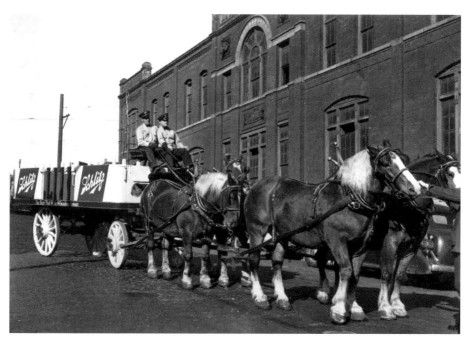

Alfred's Schlitz Team. *(Courtesy of Scott Schwarts)*

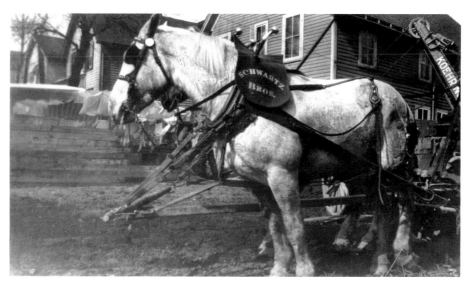

Schwartz Bros. Team. *(Courtesy of Scott Schwarts)*

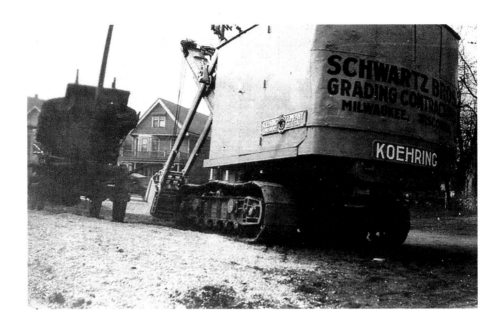

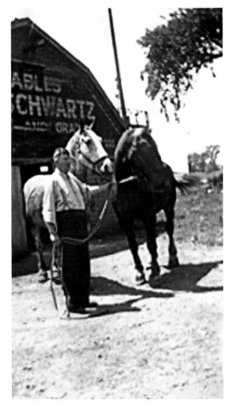

Above: Schwartz Excavation. *(Courtesy of Scott Schwarts)*

Left: Schwartz Stables, 1938. *(Courtesy of Scott Schwarts)*

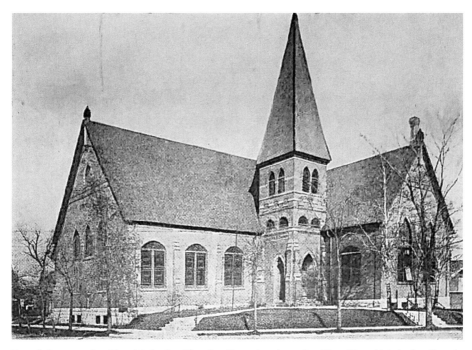

Founded in 1863, Bay View Methodist Church still stands today as Bay View United Methodist Church.

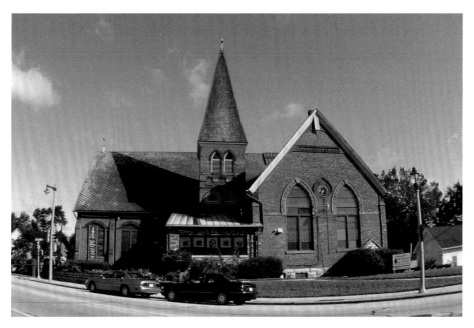

Bay View United Methodist Church today. *(Courtesy of David Evans)*

(Courtesy of David Evans)

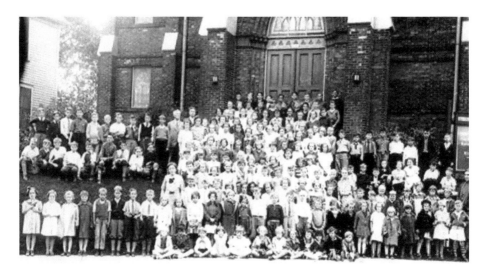

School children in front of St. Lucas, date unknown.

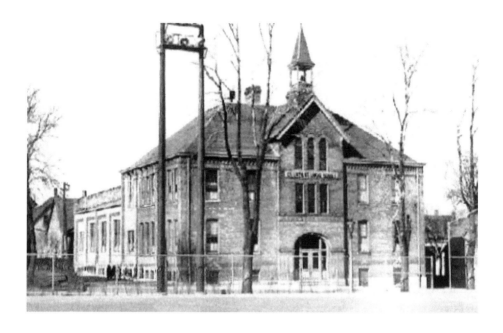

Above: St. Lucas School.

Right: St. Lucas Church with view of Bay View Library.

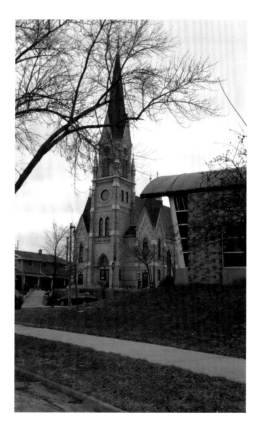

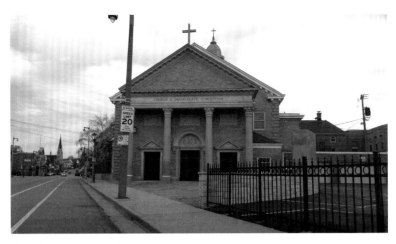

Church of the Immaculate Conception Parish.

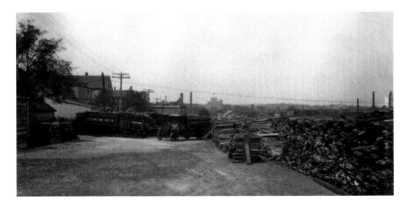

Lumberyard showing Basilica of St. Josephat in the distance.

Dover & KK.

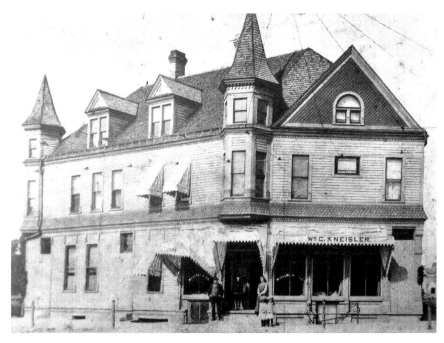

Originally built as a Schlitz tavern, The Historic White House Tavern was erected in 1891, four years after Bay View was annexed to the City of Milwaukee.

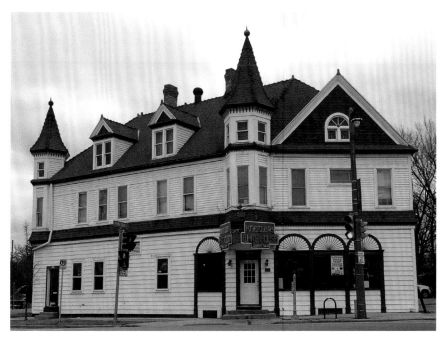

The Historic White House Tavern today.

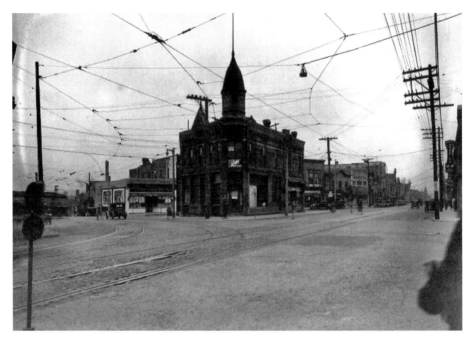

Triangle Tavern. *(Courtesy of James Bisenius)*

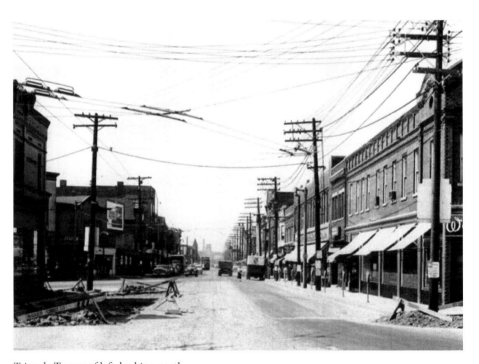

Triangle Tavern of left, looking north.

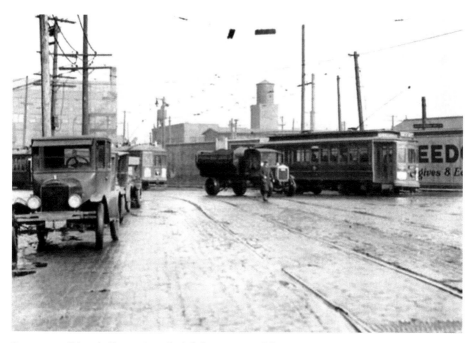

Sources say Triangle Tavern is to the left, but unsure of this.

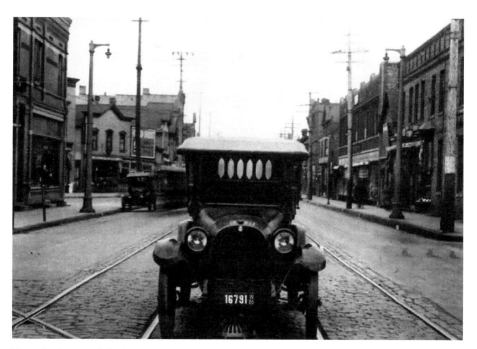

Triangle Tavern at left. *(Courtesy of James Bisenius)*

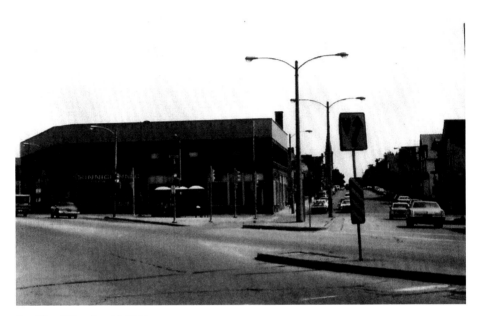

Bay View Triangle mid-1970s.

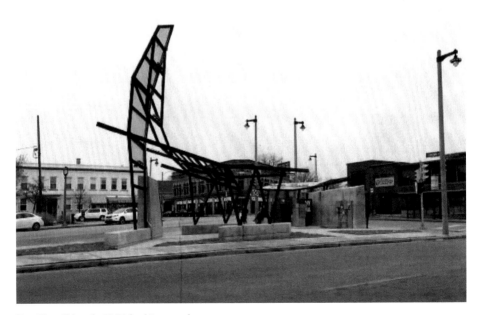

Bay View Triangle 2017, looking southeast.

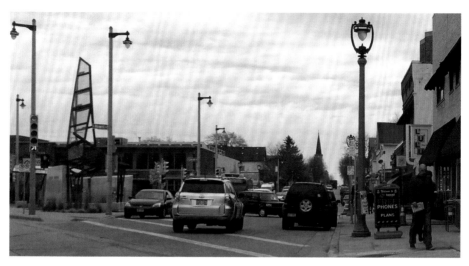

Bay View Triangle 2017, looking south onto Howell.

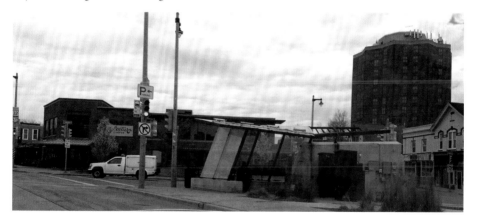

Bay View Triangle 2017.

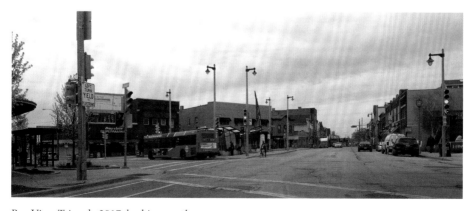

Bay View Triangle 2017, looking north.

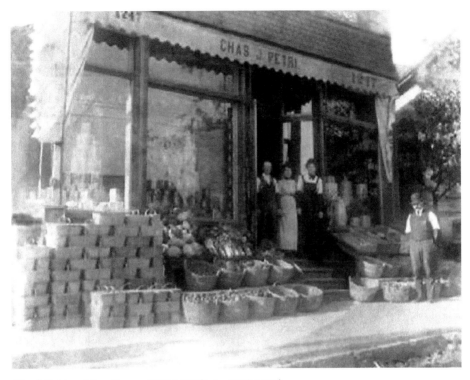

Chas J. Petri and Son Grocer, 1217 S KK (Later 2633 S KK).

Chas. J. Petri and Son

GROCERIES, FRUITS, and VEGETABLES

Tel. SHeridan 1537 2633 S. Kinnickinnic Ave.

Chas J. Petri and Son Advertising.

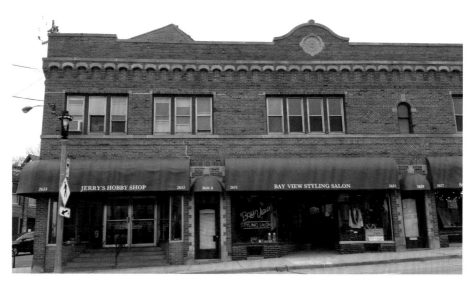

2633-27 S KK.

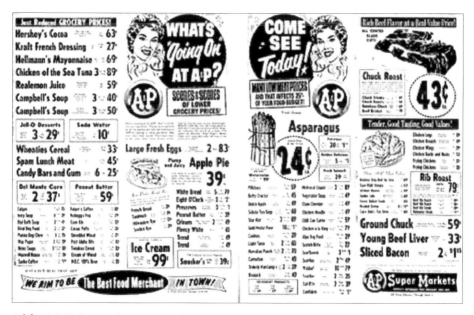

Ad for A & P Grocery Store at 2648 S KK.

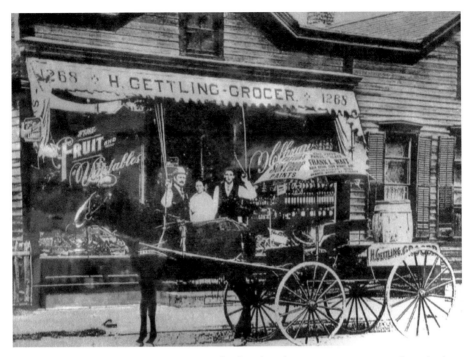

H. Gettling Grocer 1268 S KK prior to City of Milwaukee changing street names and numbering.

THE LOVELIEST HOMES HAVE FURNITURE BY

FURNITURE *Gitzel's* APPLIANCES

The Best In Appliances

FRIGADAIRE MAYTAG

2235 SOUTH KINNICKINNIC AVENUE SHeridan 1-0185

Gitzel's Department Store Ad.

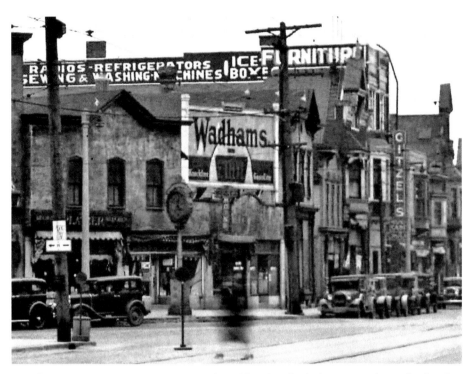

Gitzel's Department Store. 2235 S KK. Barely visible sidewalk clock is now in front of Milwaukee County Historical Society.

Some sources say this is grand opening of Gitzel's.

You Young
High School
Folks

—just at an age when you're filled with the
joy of living and want things with lots of
pep and go, will find just the kind of things
to suit you here.

TAXEY'S
DEPARTMENT STORE
POTTER AT KINNICKINNIC

Taxey's Department Store Ad.

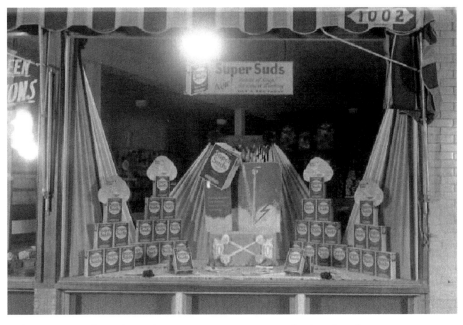

Unknown name of store located at 1002 S KK prior to City of Milwaukee changing street names and numbering.

2600 Block of S KK.

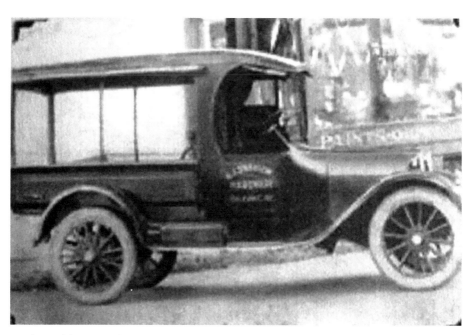

Hardware delivery truck.

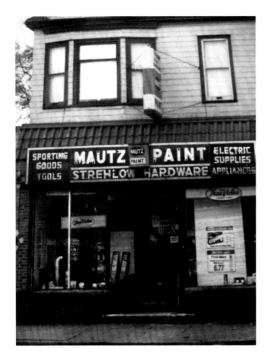

Strehlow Hardware, 2675 S KK.

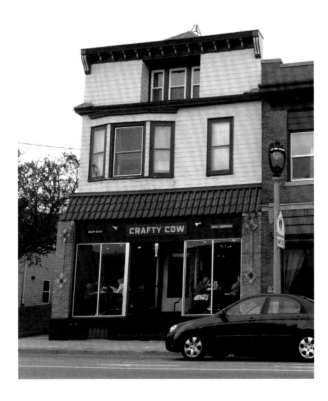

2675 S KK today.

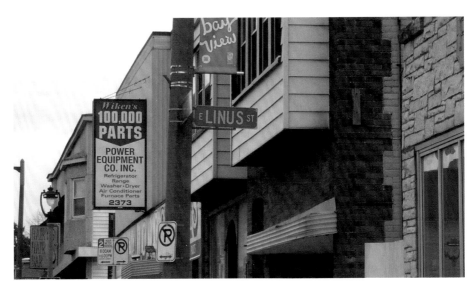

KK & Linus.

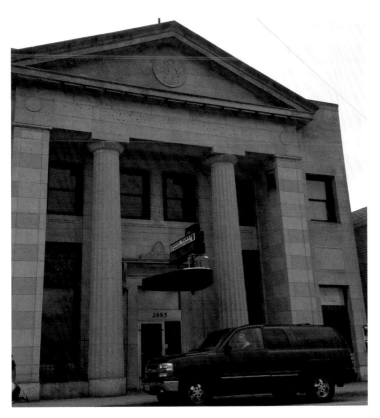

Former bank building, 2685 S KK.

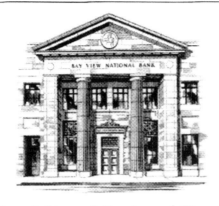

Bay View National Bank

Kinnickinnic near Russell

OFFICERS:

W. P. Westenberg, President
Fred Hoffmann, Vice President
S. M. Smith, Vice President Chas. J. Petri, Vice President
C. M. Glocke, Vice President A. H. Lambeck, Vice President
W. E. Morris, Cashier
L. H. Grosbier, Asst. Cashier E. H. Lewnau, Asst. Cashier

DIRECTORS:

J. E. Auten	Carl F. Geilfuss	W. V. Nelson
Wm. H. Correll	Fred Hoffmann	Chas. J. Petri
Geo. C. Dreher	A. W. Johnson	S. M. Smith
W. R. Franzen	J. D. Maurer	W. P. Westenberg
B. W. Fueger	G. C. Mueller	E. L. Wood

Left: Bay View National Bank ad.

Below: WI Territory bank note.

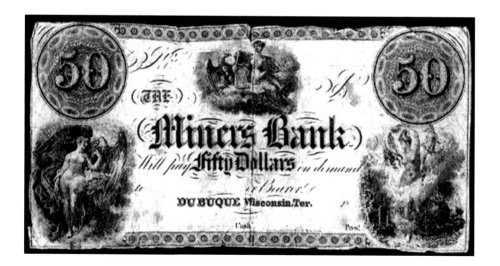

3

THE AVENUE

A CCORDING TO AN article in *The Daily Milwaukee News* on Thursday, May 13, 1869, there were plans for the planking of the sidewalks "on Kinnickinnic Avenue to the south line of Smith's addition," which demonstrates the popularity of KK, as only well-traveled streets were planked during this time. Although for a very long time KK was the primary route in and out of the Bay View area, the need for transportation into and out of Bay View began to be discussed right around the ending of World War II. On Thursday, January 1, 1942, Hales Corners, Wisconsin, newspaper the *Voice-Herald* reported of a coordinated plan for Lake Drive to extend southward:

> A detailed "co-ordinated plan" for the southward extension from downtown Milwaukee into Bay View was submitted recently by the Milwaukee land commission. Any construction based on the plan, it was explained, will have to await the end of the war because of the need for building materials in defense. Among the projects planned in connection with the southward drive extension are a connecting vehicular road near E. Clybourn St. in Milwaukee; a bridge or tunnel at the Milwaukee river mouth to connect with the Lincoln Memorial drive; a traffic connection to the drive at E. Conway St. in Bay View; a public shelter for small craft at the foot of E. Russel St. in Bay View; and the ultimate purchase of privately owned property east of S Shore drive between E Russel Ave. and E. Nock St. and east of S. Superior St. between E. Meredith St. and E. Oklahoma Ave as parkway for the extension of Lincoln Memorial drive.

It is known that many Bay Viewites have historically been against the development of the Hoan Bridge, which links downtown Milwaukee to Bay View. Residents held organized protests against the construction of the bridge in an effort to keep Bay View secluded and private, but construction began in 1970. It appears plans for this connection, as well as the Lake Parkway, had been discussed and proposed long before this.

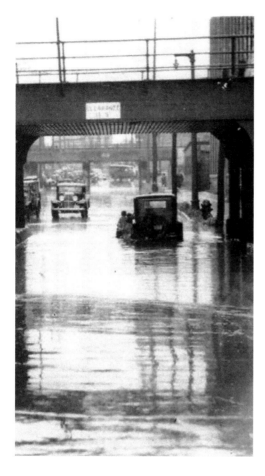

Left: Flooded cars at KK & Becher.

Below: Site of flooded cars at KK & Becher

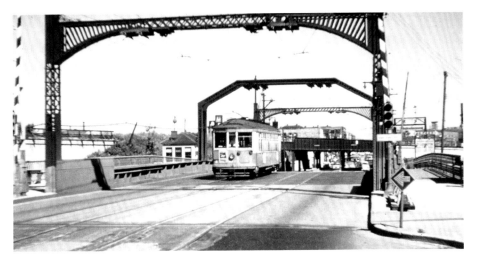

Streetcar Route 11. *(Courtesy David Evans)*

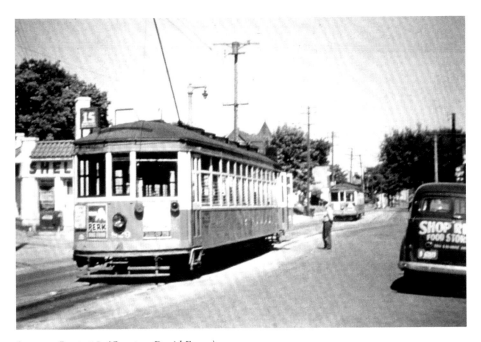

Streetcar Route 15. *(Courtesy David Evans)*

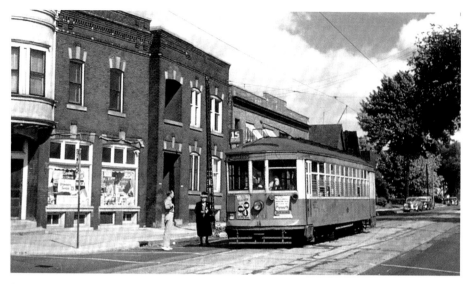

Streetcar Route 15. *(Courtesy David Evans)*

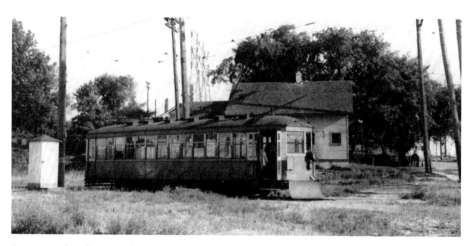

Streetcar Lakeside Route. *(Courtesy David Evans)*

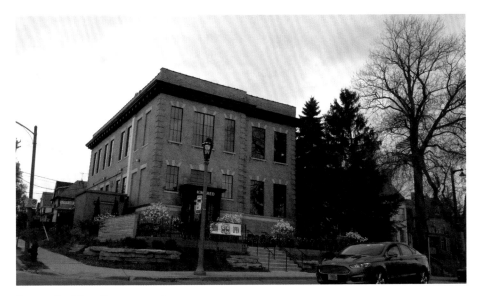

Former Bay View Freemasons site.

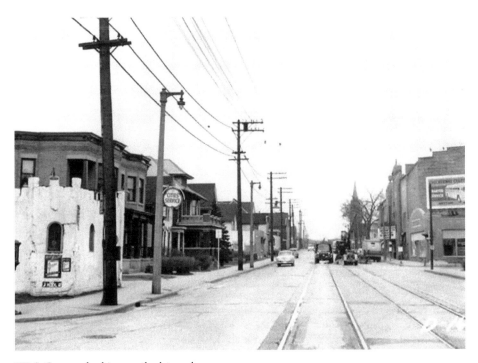

KK & Conway, looking south, date unknown.

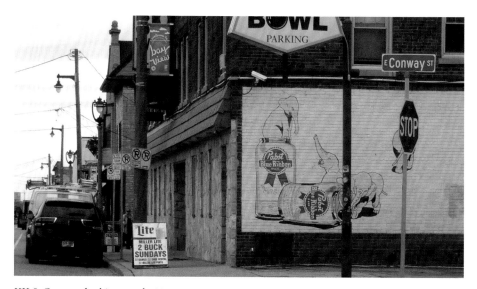

KK & Conway, looking north, 2017.

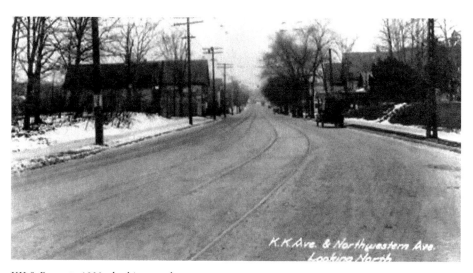

KK & Bennett, 1920s, looking north.

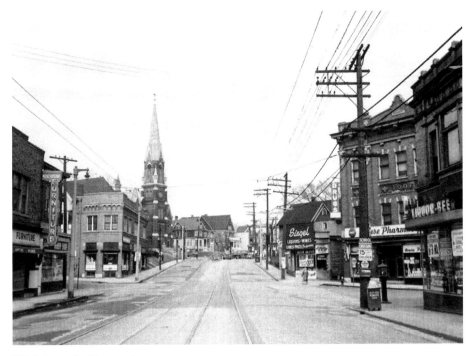

KK & Potter, looking north.

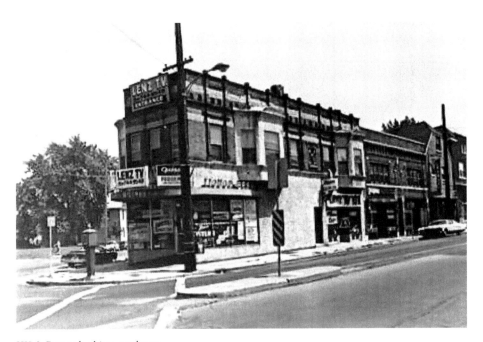

KK & Potter, looking southeast.

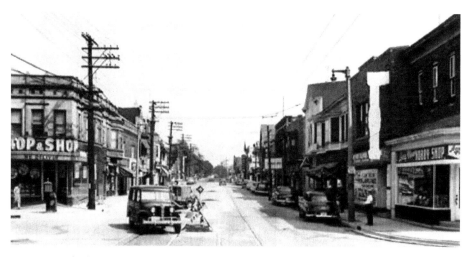

KK & Potter, looking south.

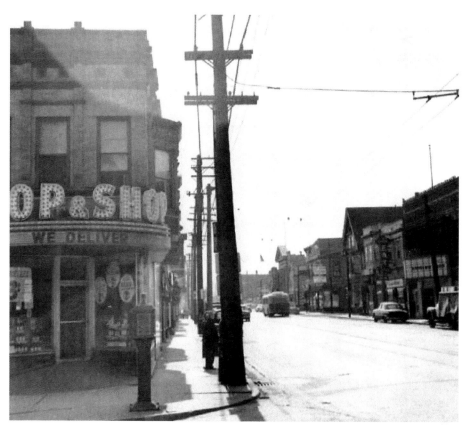

KK & Potter, 1950s.

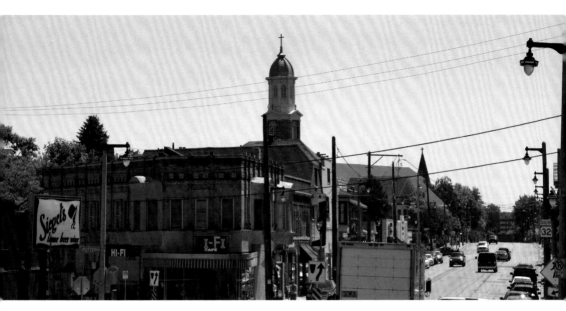

KK & Potter, looking south.

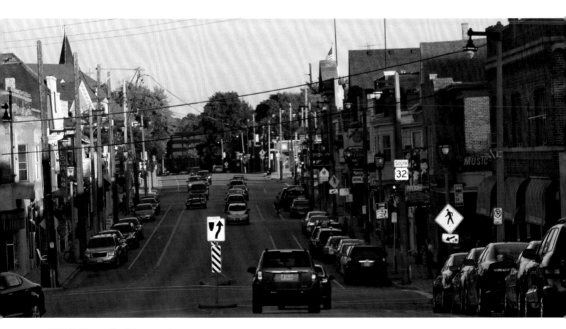

KK & Potter, looking south.

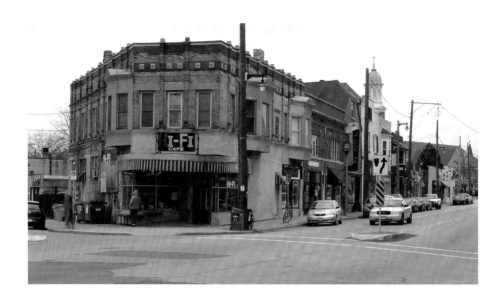

Above: KK & Potter, Hi Fi Cafe.

Left: Marching on KK. *(Courtesy of Bay View Historical Society)*

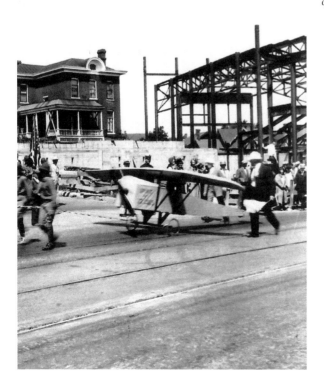

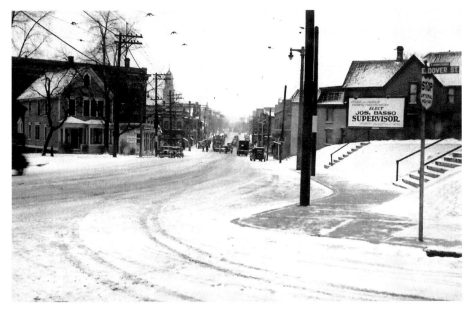

KK 1920s. *(Courtesy of Bay View Historical Society)*

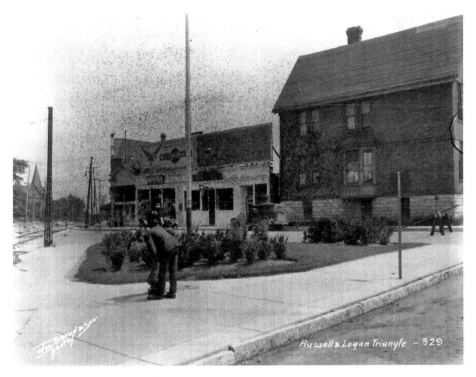

KK & Logan Triangle, date unknown.

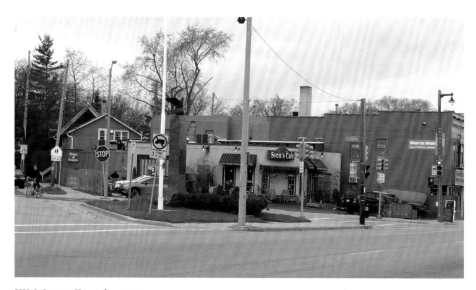

KK & Logan Triangle, 2017.

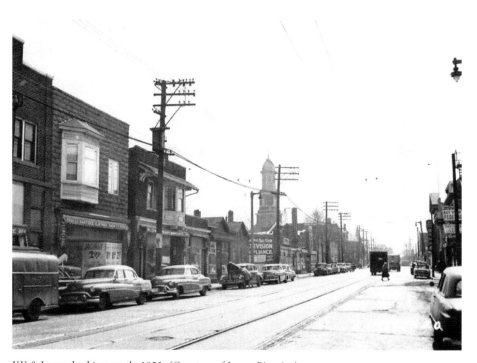

KK & Logan looking south, 1953. *(Courtesy of James Bisenius)*

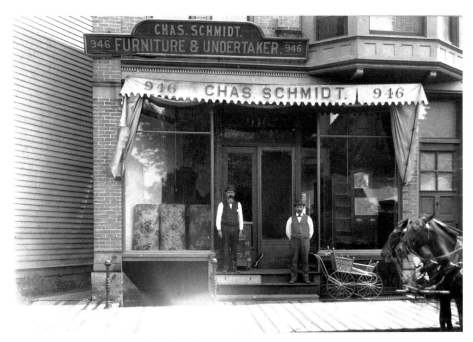

Chas Schmidt Furniture and Undertaker, 946 S KK prior to City of Milwaukee changing street names and numbering. *(Courtesy of Jean Larsen)*

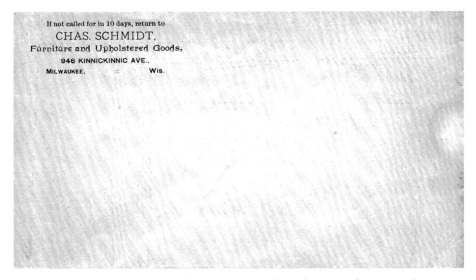

If not called for in 10 days, return to
CHAS. SCHMIDT,
Furniture and Upholstered Goods,
946 KINNICKINNIC AVE.,
MILWAUKEE, :: WIS.

Chas Schmidt Furniture and Undertaker stationary envelope. *(Courtesy of Jean Larsen)*

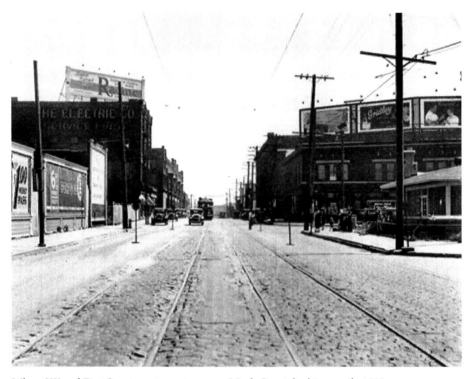

Where KK and First Street meet, coming upon Maple Street, looking south, 1930s.

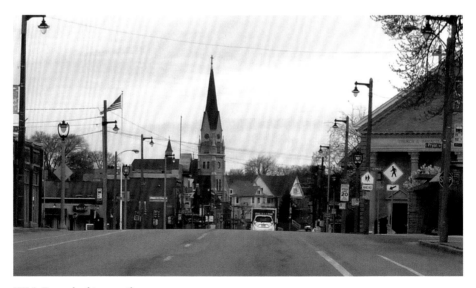

KK & Pryor, looking north.

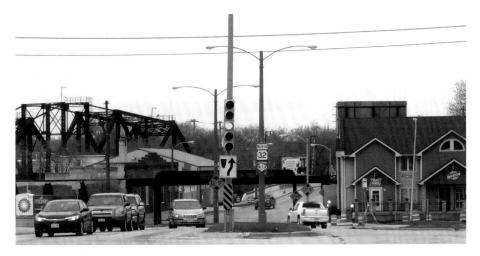

KK & Becher, looking north.

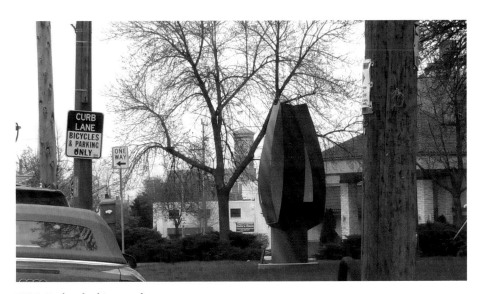

KK & Becher, looking north.

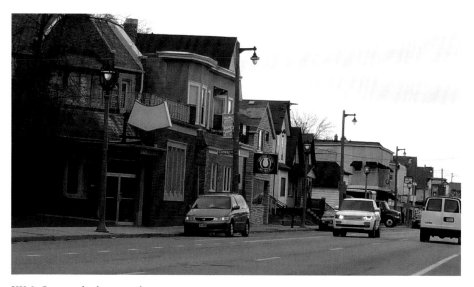

KK & Conway, looking north.

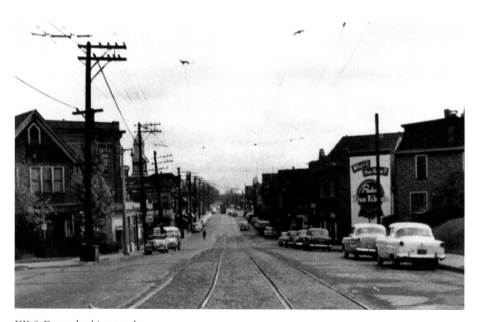

KK & Dover, looking south.

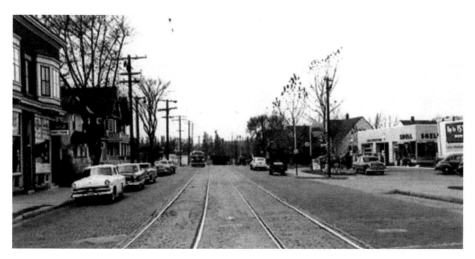

KK & Ellen, looking north.

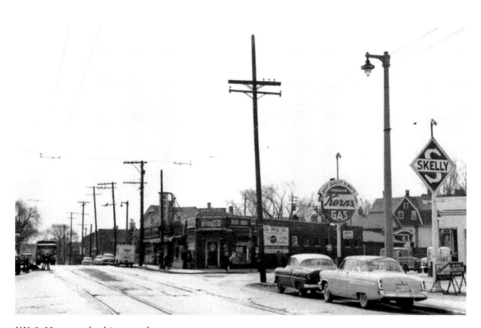

KK & Herman, looking south.

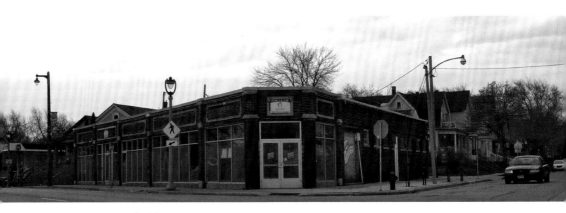

KK & Herman building.

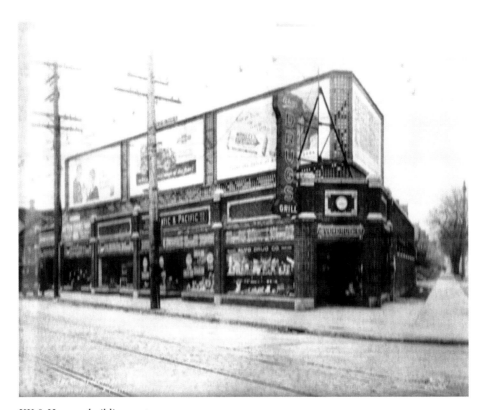

KK & Herman building past.

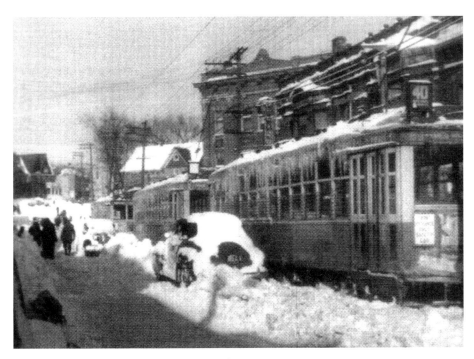

KK & Lenox 1947. *(Courtesy of James Bisenius)*

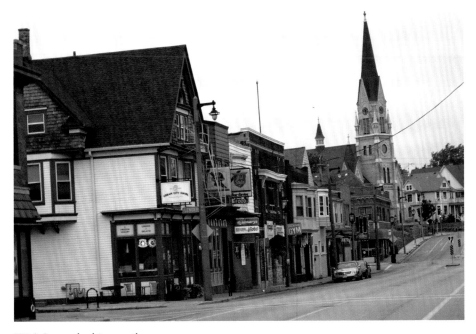

KK & Lenox, looking north.

KK & Lincoln.

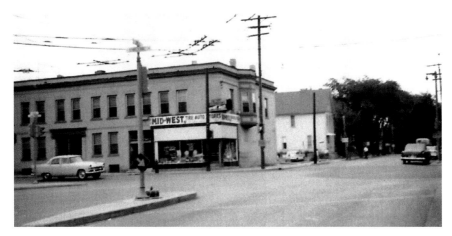

KK & Lincoln, looking east, 1961. *(Courtesy of Bay View Historical Society)*

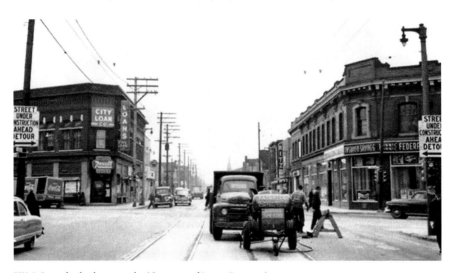

KK & Lincoln, looking south. *(Courtesy of James Bisenius)*

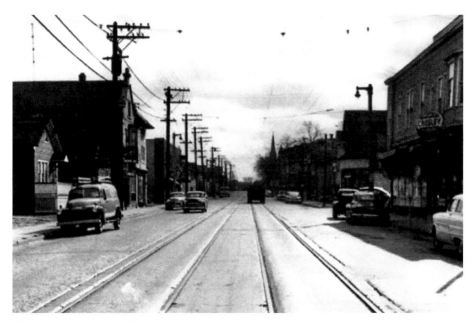

KK & Linus, looking south.

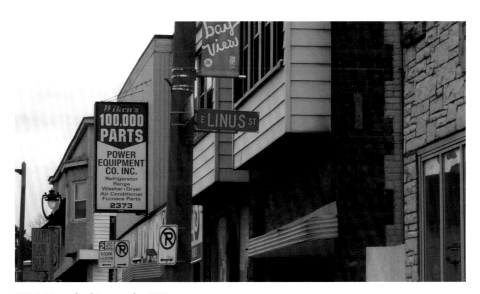

KK & Linus, looking south, 2017.

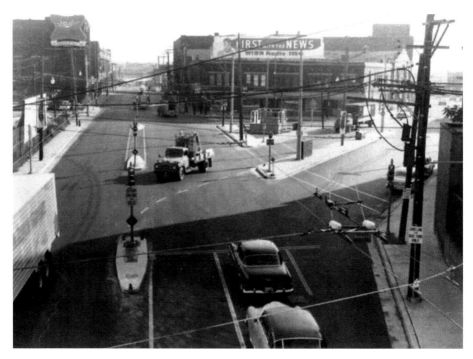

KK & Mitchell. *(Courtesy of James Bisenius)*

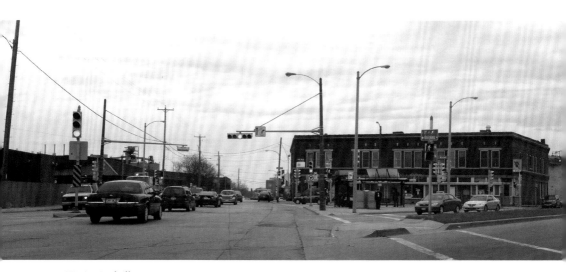

KK & Mitchell, 2017.

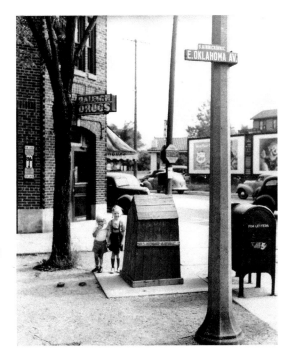

Right: KK & Oklahoma. *(Courtesy of Bay View Historical Society)*

Below: KK & Oklahoma, looking south past Oklahoma Avenue. *(Courtesy of Pastor Andrew Oren)*

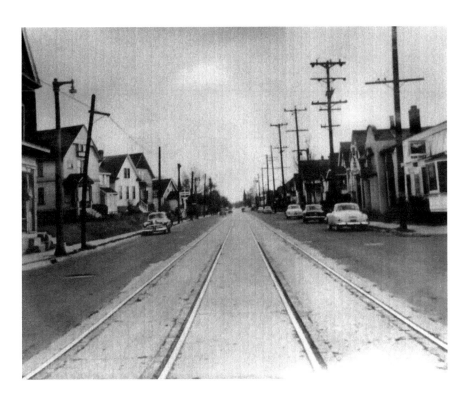

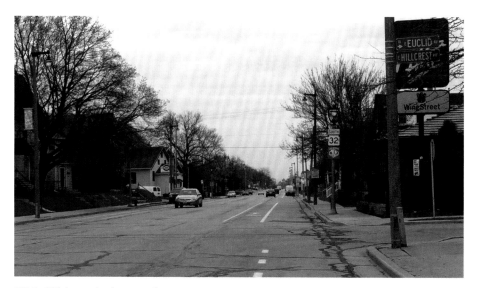

KK & Oklahoma, looking south 2017.

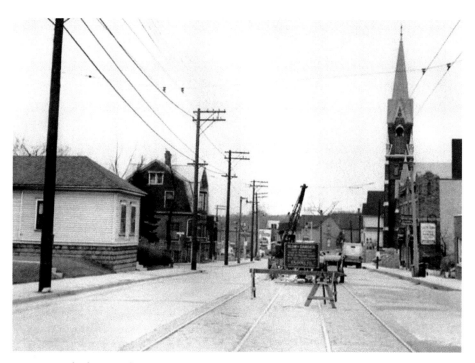

KK & Otjen, looking south.

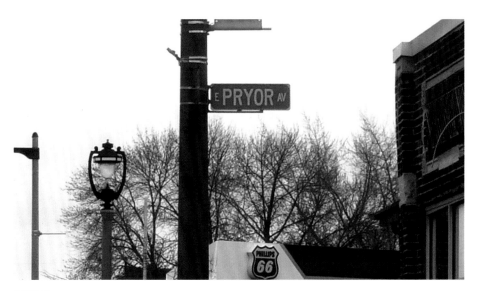

KK & Pryor.

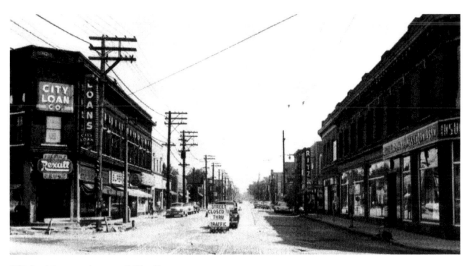

KK, looking south toward Ritz Restaurant.

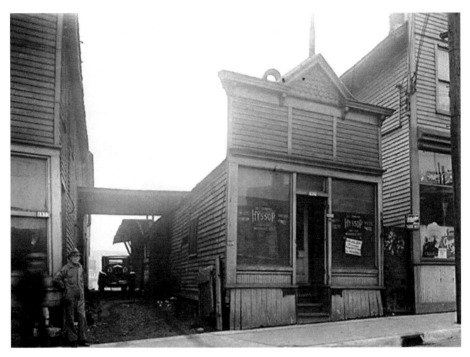

1829 S KK, prior to City of Milwaukee changing street names and numbering.

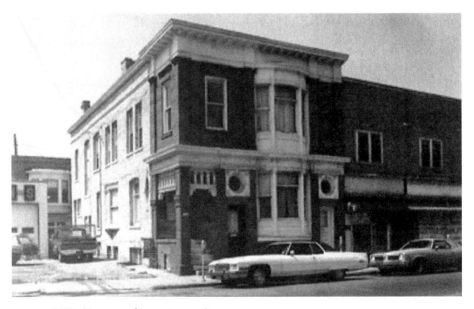

2329-31 S KK. *(Courtesy of James Bisenius)*

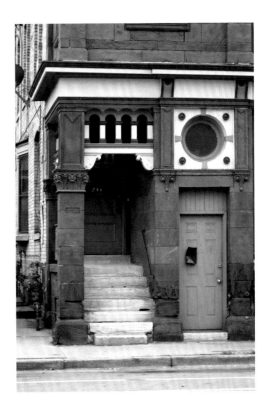

Right: 2329-31 S KK.

Below: 2329-31 S KK.

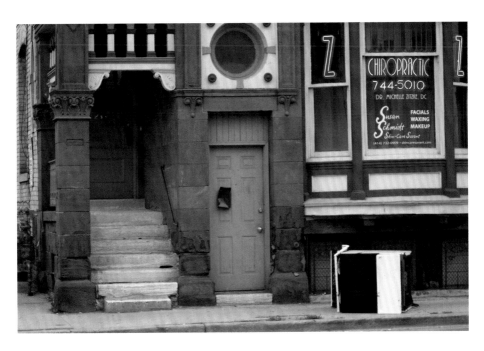

2363 S KK.

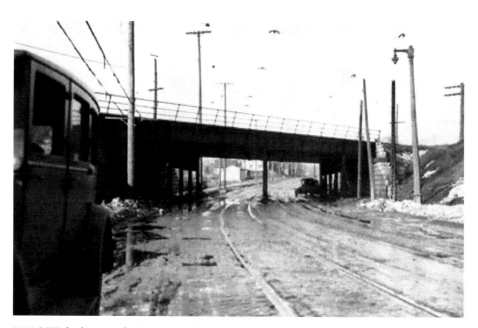

2860 S KK, looking north. Outpost would be just beyond the bridge.

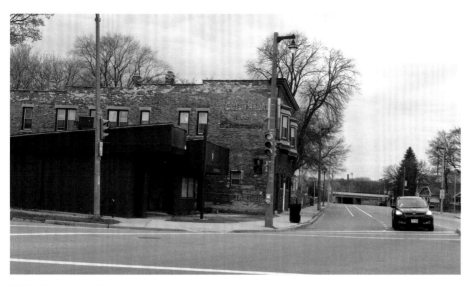

KK & Bennett, looking north.

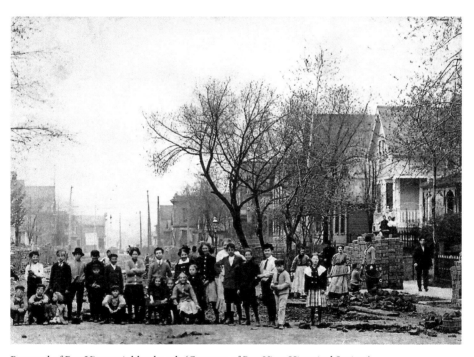

Postcard of Bay View neighborhood. *(Courtesy of Bay View Historical Society)*

Back of postcard. *(Courtesy of Bay View Historical Society)*

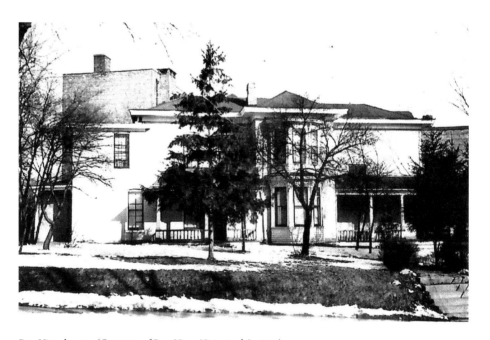

Bay View home. *(Courtesy of Bay View Historical Society)*

Right: Modern business in historic building.

Below: Old Avalon Theater.

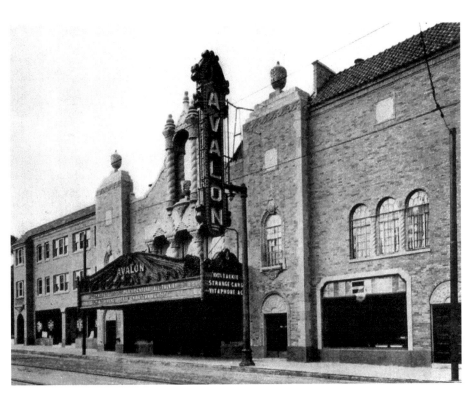

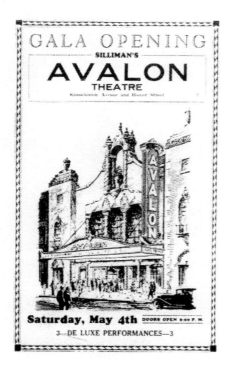

Left: Avalon Theater advertising.

Below: Modern Avalon Theater.

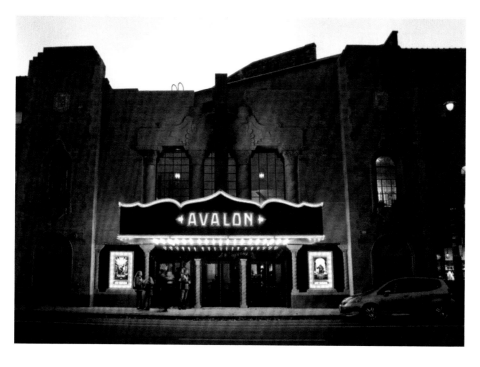

4

THE RIVER

The Milwaukee Sentinal reported on Wednesday, June 13, 1866:

> a dispatch from Washington announces that the House Naval Committee have reported a
> bill giving the President authority wherever in his judgment public interest requires it, to
> establish at Cleveland, Grand Have, and Milwaukee, suitable navy yards or naval depot for
> the protection of American commerce on the great lakes, and will affix upon this city as the
> location of the first one established.

THE SHIPYARD HERE pictured launching the U. S. S. *Claiborne* into the KK River is one of 26 ships built by Froemming Bros. Shipyard at this location. The property became Wagner Iron Works sometime in the 1950s, followed by Olson Marine in 1969. The property's longest use as a yacht storage facility was as Milwaukee Marine under owner and operator James Bisenius, and served for many years as the home and workplace of the author.

The final voyage of the S. S. *Edmund Fitgerald* began on November 9, 1975, at the Burlington Northern Railroad Dock No. 1, in Superior, Wisconsin. She would sink the following night during a ferocious storm enroute to a steel mill in Detroit, MI. On November 10, 1974, all 29 crewmembers lost their lives aboard the largest ship to sink in the Great Lakes due to bad weather. The *Fitzgerald* has Milwaukee ties that reach farther than just her visit to Jones Island in 1959, however. Launched in Detroit on June 7, 1958, the ship was named after the president of the company that owned her: Northwestern Mutual Life Insurance. Mr. Fitzgerald came from a long line of Great Lakes ship captains, his father having a ship named after him, the *W. E. Fitzgerald*. Although the *Fitzgerald* sank in Lake Superior, she was at the time in Canadian waters and thus is not included in many histories of Wisconsin shipwrecks. The SS *Edmund Fitzgerald* became immortalized by Gordon Lightfoot, an Ontario-born singer, who composed and recorded the song "The Wreck of the Edmund Fitzgerald" in 1976.

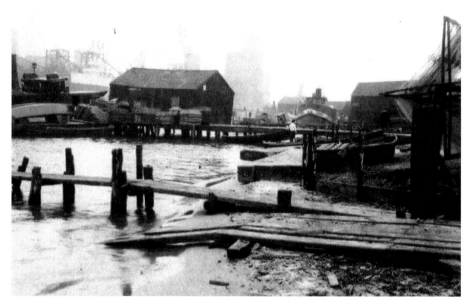

Jones Island. *(Courtesy of James Bisenius)*

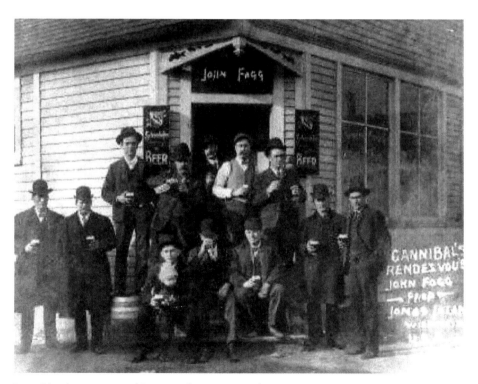

Jones Island tavern, 1906. *(Courtesy of James Bisenius)*

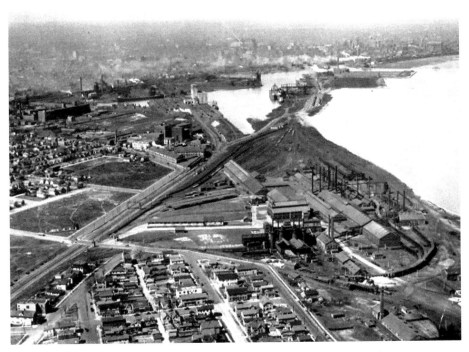

Jones Island, looking toward downtown Milwaukee. *(Courtesy of James Bisenius)*

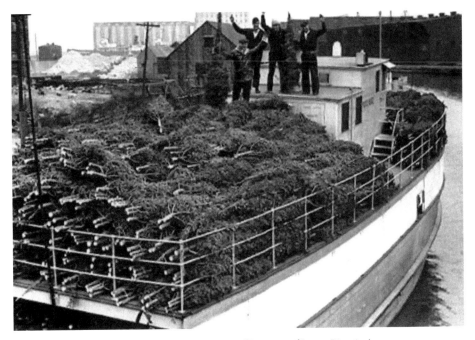

Ship delivering Christmas trees on the KK River. *(Courtesy of James Bisenius)*

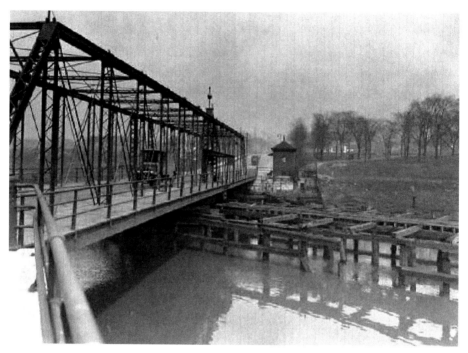

KK River Bridge. *(Courtesy of James Bisenius)*

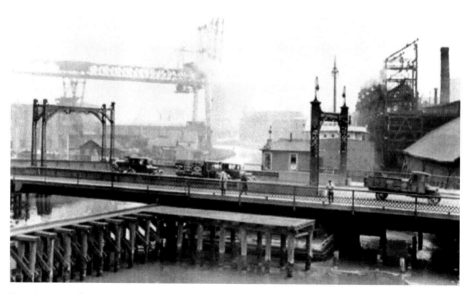

First Street Bridge overlooking KK River. *(Courtesy of James Bisenius)*

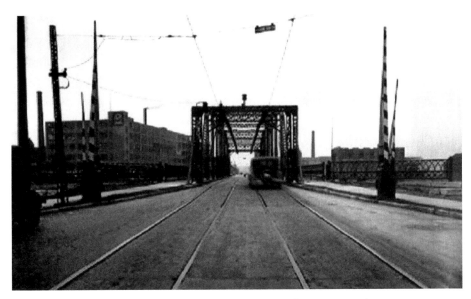

First Street Bridge over KK River, looking south. *(Courtesy of James Bisenius)*

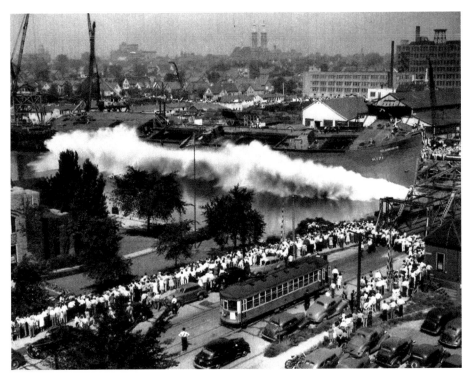

Launch of warship USS *Claiborne* into KK River from Froemming Bros. Shipyard at 1933 S First Street, September 3, 1944. *(Courtesy of James Bisenius)*

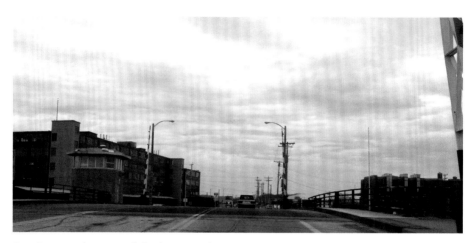

First Street Bridge. Just to left is location of USS *Clairborne* launch.

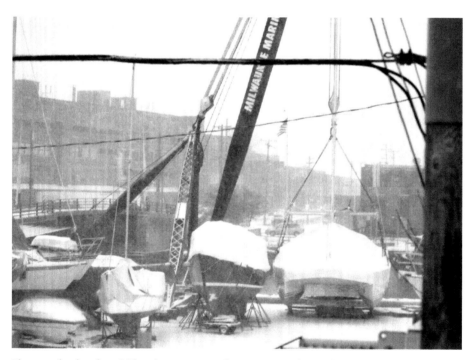

Photograph taken from Milwaukee Marine Yacht Center, Inc., former location of Froemming Bros. Shipyard.

KK & Becher, approaching Maple Street.

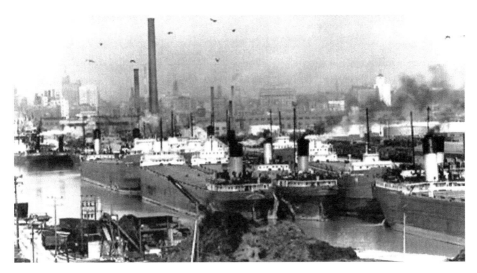

Ships docked in river. *(Courtesy of James Bisenius)*

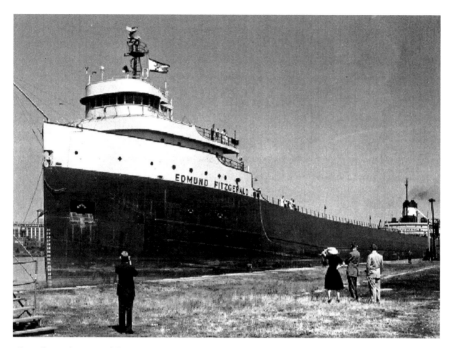

The *Edmund Fitzgerald* visits Milwaukee in 1959. *(Courtesy of James Bisenius)*

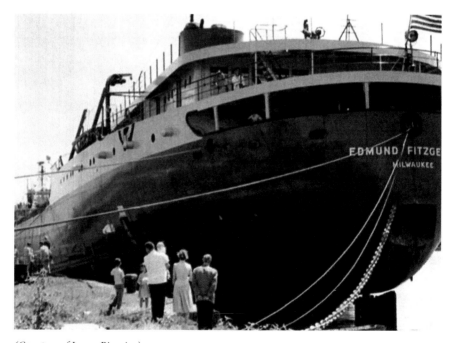

(Courtesy of James Bisenius)

CONCLUSION

S URROUNDING KINNICKINNIC AVENUE is Bay View, its history as long as the old Indian trail that graces the name of its most popular street. The changes and growth, the sorrows and triumphs of a geographic area as small as one single street in one fixed area directly parallels that of the larger surrounding city, an even vaster state, and the greater nation as a whole. From the Native American traveling from one area to

another on foot to the pioneer with horse and wagon, from the horse and buggy along planked sidewalks to the route #15 streetcar on paved streets, KK has witnessed the history of America. Included in the history of KK and Bay View are tales of the lakeshore, island, and river that border the area, from the fur traders' birchbark canoe to the Navy's USS *Clairborner* in the KK River, from the entrance to Milwaukee along Lake Michigan to the opening of the Port of Milwaukee alongside Jones Island. The history of KK and Bay View is representative of the history of America, for local history *is* national history.

Kinnickinnic Avenue remains the main artery of Bay View, and bustles full of restaurants and specialty shops, nightclubs and residences, intertwining the historic with the modern, in tandem with all of America, and all of which can be described as "it is mixed," or Kinnickinnic.

Appendix

Kinnickinnic Avenue businesses, according to advertisements in both the 1938 Bell Telephone Book and the 1945 Bay View High School Oracle (old addresses listed in parentheses are pre-1930 before Milwaukee changed the street numbering).

2023 S KK	Ram's Head Bar
2127	Luetzows South Side Laundry
2133	B.S. Wisnewski American Co. Supply House
2224	Laufenberg Bros. – roofing, etc.
2235	Gitzel's Furniture
2250	Gilles & Pottinger Co. – real estate
2272	J & W Soltes Jewelers
2301	KK Federal Savings & Loan
	Dean Cardinal Insurance (Upper)
2330	Alma & Baljanz Flowers
2332	Matzen Fuel Co.
2346	Burnham's Lawnmower Grinding
2363	Martin H. DuMezInsurance & Stamp Co.
2366	Bay View Tire & Supply
2401	Gerling Bros. – coal, wood, coke
2483	E.F. Wood Photographer
2486	J.W. Nieman & Sons – funeral home
2510	Awe Awning Co.
2519	Dr. Marian Lewis
	Dr. J.P. Zentner – dentist
2549	Don's Service Station
2594	Pate Oil Co. Service Station

2611	Rev. Ph, H Koehler (St. Lucas Church)
2633	Chas J. Petri & Sons – grocery
2635	Corner Sweet Shop – Mrs. Stathas proprietor
2626	Bay View Fish Market
2627	Glady's Home Bakery
2628	Bay View Cleaners & Tailors
2631	Mierendorf Foot Correction Institute
2631A	Dr. H.W. Hein – Dentist
2632	Matthew Schauer Tavern
2633	Charles Petri & Son Grocery
2635	The Corner Sweet Shop – 1st floor
	Dr. G.L. Evans, Dentist – 2nd floor
2637	Baker Furniture Company
2640	Stop & Shop Liquor
2643	Schneider Drug Store
2644	Glow Soda Grill (old address 1244 KK)
2645	Elliot Arthur Tavern – 1st floor
	Dr. F.X. McCormick – 2nd floor
	Dr. Robert E. McCormick – 3rd floor
2648	A & P Food Store
2651	Mirth Theater
2652	George Glisch Meat market
2657	Peter Pan Restaurant
2660	Bay View Hat & Beauty Shoppe
2671	Bay View Building & Loan
	Bullock Attorney & Insurance – 2nd floor
	Tippecanoe Building & Loan – 2nd floor
2675	Strehlow Hardware (Old address 1289 KK)
2676	Bay View Sausage Shop
2680	Taxeys Department Store
2681	Bay View Sun Fruit Market
2685	Bay View National Bank (To become First Wisconsin Bank)
2787	Bay View Nationsl Bank Building
	YMCA 2nd floor
2689	Dr. O'Hara Physician Office
	Dr. Roman J. Stollenwerk – Dentist
2691	Avalon Cleaners & Tailors
2697	Paul J. Grunau Plumbing and Heating (Old address 1307 KK)
2693	Scheinerts Bakery

2695	Buske Chiropodist
2698	Gibson Real Estate & Insurance
2688	Fred Burow Service Station
2912	Art Lench Super Service Station
2993	Starks Market
3099	Transfer Food Market
3104	Dr. John P. Baleigh – dentist
3106	A.H. La Ranze – tailor

Bibliography

Austin, H. Russell., *The Milwaukee Story: The Making of an American City* (Milwaukee: The Journal Company, 1946)

Crews-Nelson, Marilyn B., et al., *Wisconsin's Past and Present: A Historical Atlas* (Madison: University of Wisconsin Press, 1998)

Hunt, Roger H., *Early Milwaukee: Papers from the Archives of the Old Settlers' Club of Milwaukee County 1830-1890* (Madison: Roger H. Hunt, 1977)

Kellog, Louise Phelps., *The French Râegime in Wisconsin and the Northwest* (Madison: State Historical Society of Wisconsin, 1925)

Korn, Bernhard C., *The Story of Bay View* (Milwaukee: Milwaukee County Historical Society, 1980)

Francis Parkman, *The Conspiracy of Pontiac* (New York: Collier Books, 1962), 359.

Skinner, Claiborne A., *The Upper Country: French Enterprise in the Colonial Great Lakes* (Baltimore: Johns Hopkins University Press, 2008)

Wyman, Mark., *The Wisconsin Frontier* (Indianapolis: Indiana University Press, 1998)